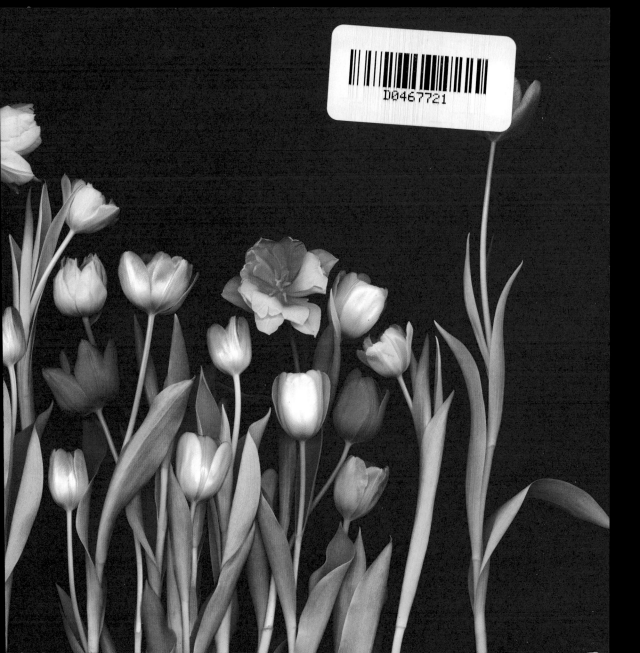

D0467721

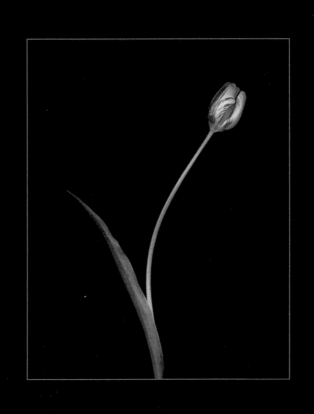

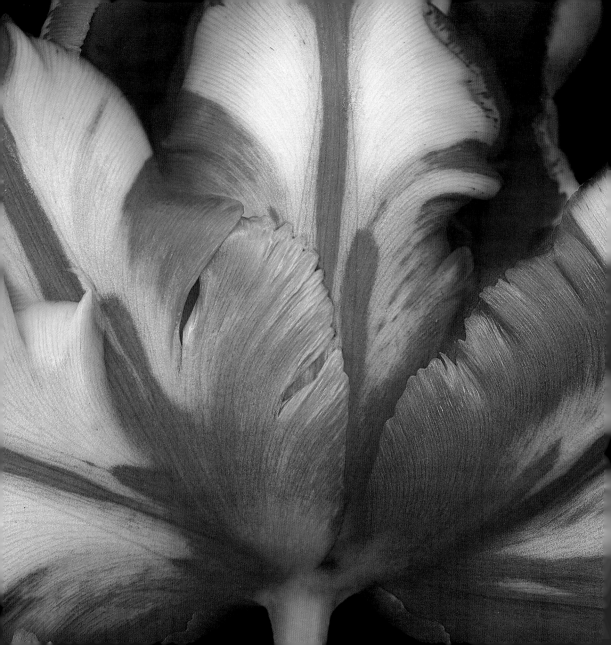

THE INFINITE
TULIP

HAROLD FEINSTEIN

BULFINCH PRESS

AOL TIME WARNER BOOK GROUP · BOSTON · NEW YORK · LONDON

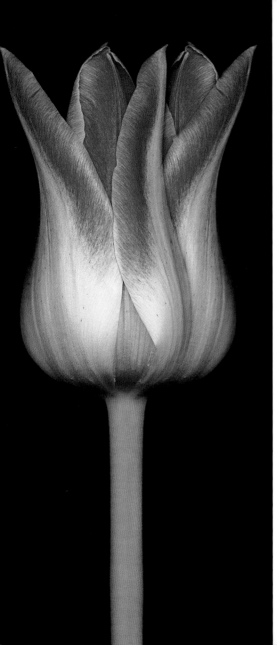

For Sarah, Shaler, Adam, and Gjon

ACKNOWLEDGMENTS

I wish to thank the following people: Jo-Anne S. Ohms of John Scheepers and Van Engelen for her generous advice about tulips; Lance Hidy for his strong design and perpetual input in the editing; Cindia Sanford, whose personal involvement with and love of flowers has been a continuous inspiration; Cherie Beaumont for her organizational support.

I also want to thank Jill Cohen, publisher, and Michael Sand, editor, at Bulfinch for their enthusiastic efforts on behalf of this book.

My wife and soulmate, Judith, for her warmth, wisdom, and love.

Lastly, I want to thank Fabia Barsic-Ochoa and Dan Steinhardt of Epson America, whose printers and scanners made this project feasible. HF

First Edition
ISBN 0-8212-2874-9
Library of Congress Control Number 2003112726

Bulfinch Press is a division of AOL Time Warner Book Group.

Design by Lance Hidy
PRINTED IN ITALY

PAGE ONE: PRINCESS IRENE
FRONTISPIECE: SPLENDORA
LEFT: ELEGANT LADY

THE INFINITE TULIP

In teaching photography, my basic instruction is "When your mouth drops open, click the shutter!"

When I was photographing the extraordinary variety of tulips, with my mouth dropping open almost continuously, the phrase "the infinite tulip" burst from my mouth.

And so the title of this book was born.

Feathery petals, graceful stems with leaves of a dancer, colors from chrome yellow to the whitest of white – such was the beauty, it was almost unbearable. Were it not for the medium of photography, it would have been thus for me. When I am asked about my technique, I reply, "A prayer"–

A prayer of gratitude:
gratitude for the beautiful flowers, and
gratitude for the eyes to see them with.

FRINGED CARNIVAL

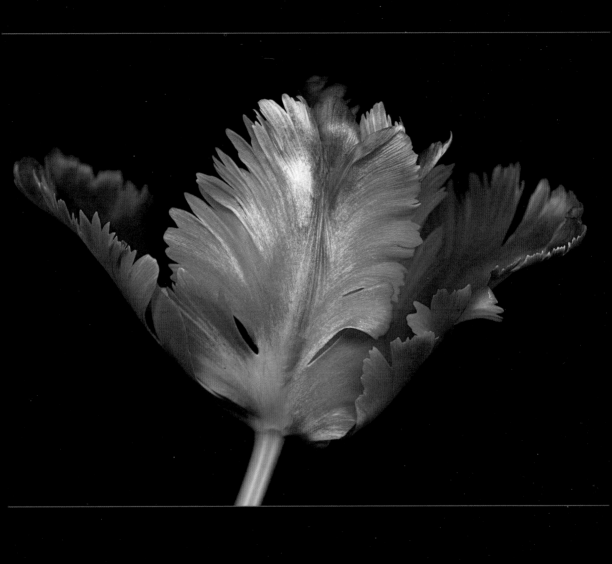

SALMON PARROT

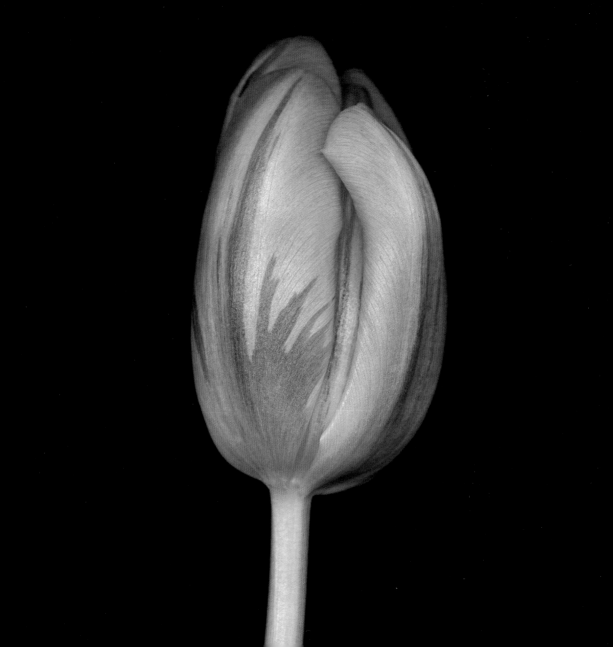

FRINGED FLAIR

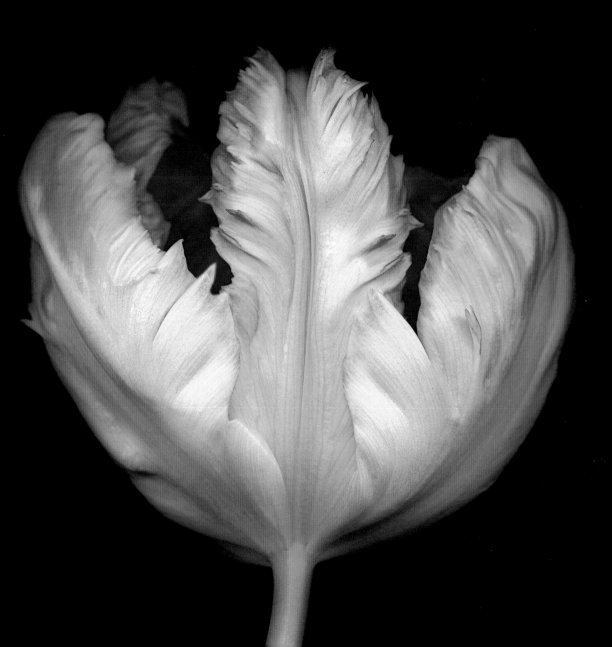

YELLOW PARROT

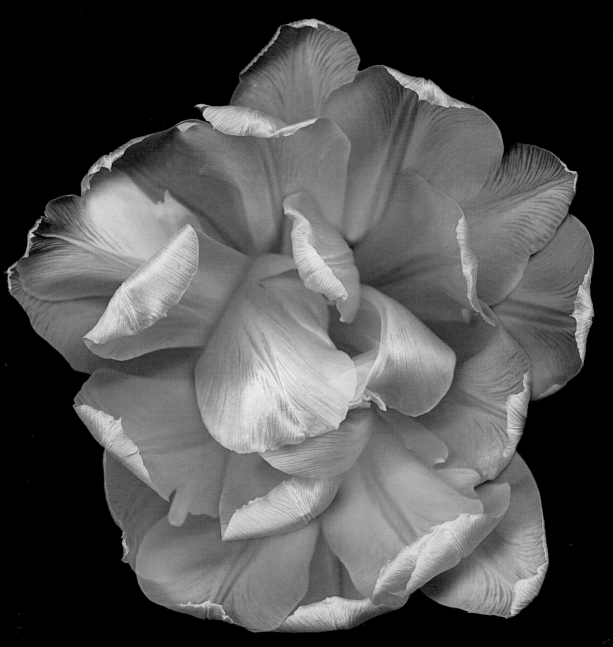

WIROSA

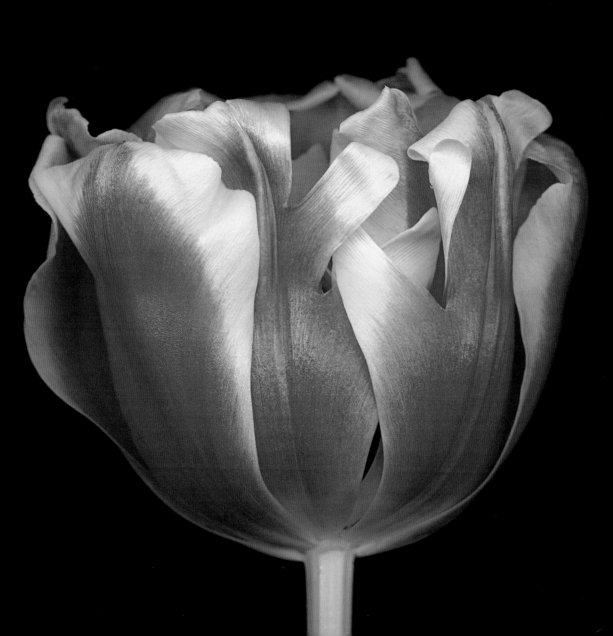

AVIGNON

OVERLEAF

FANCY FRILLS

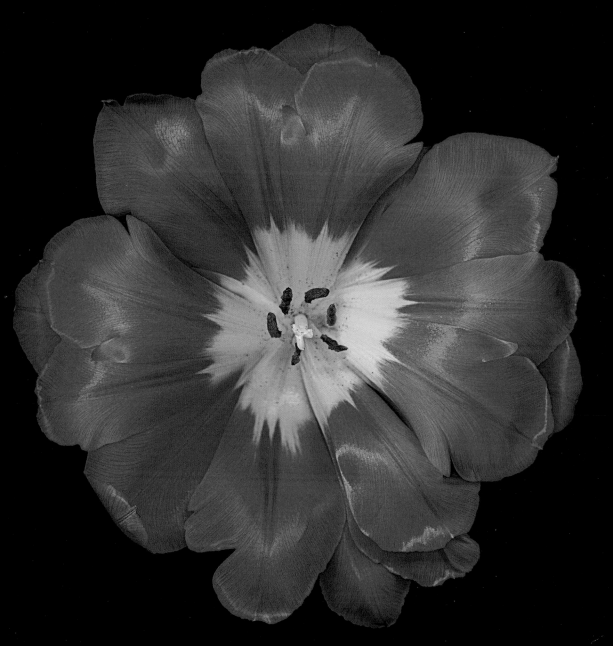

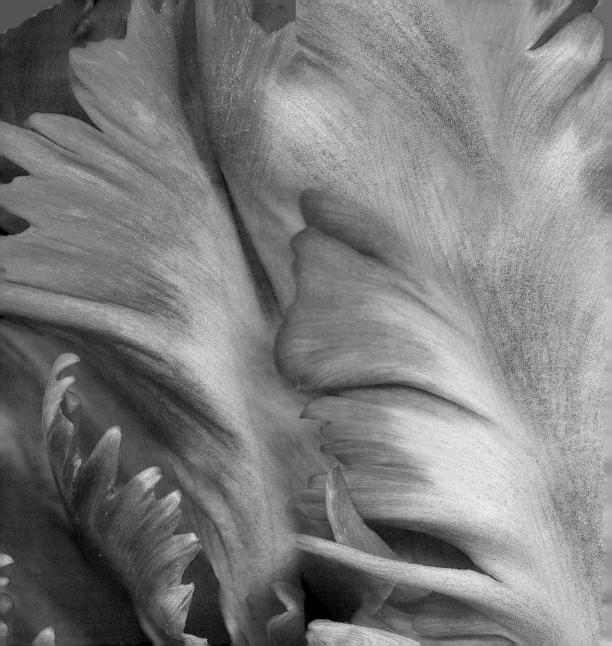

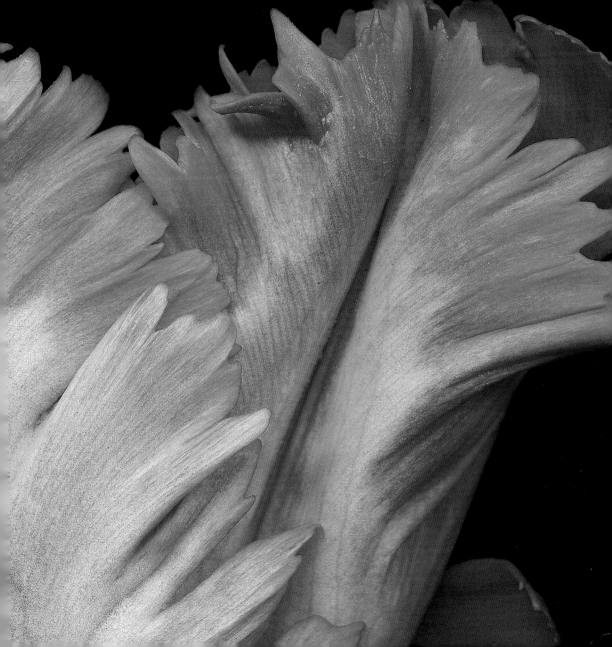

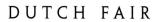

DUTCH FAIR

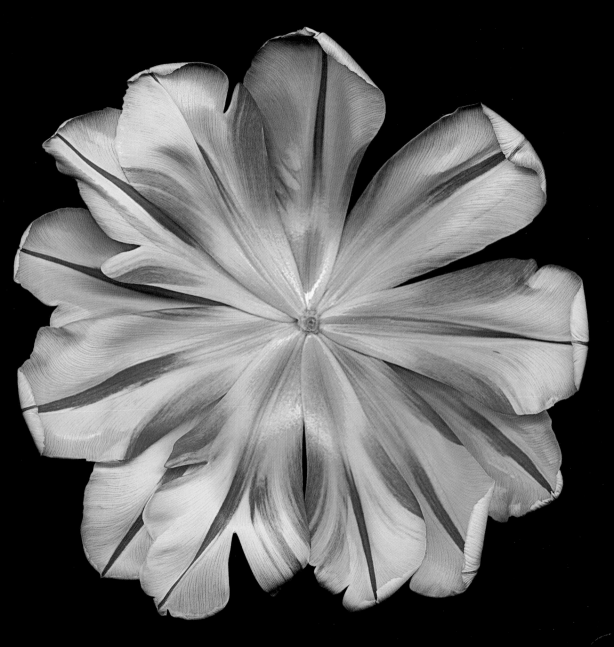

RED WHITE PARROT

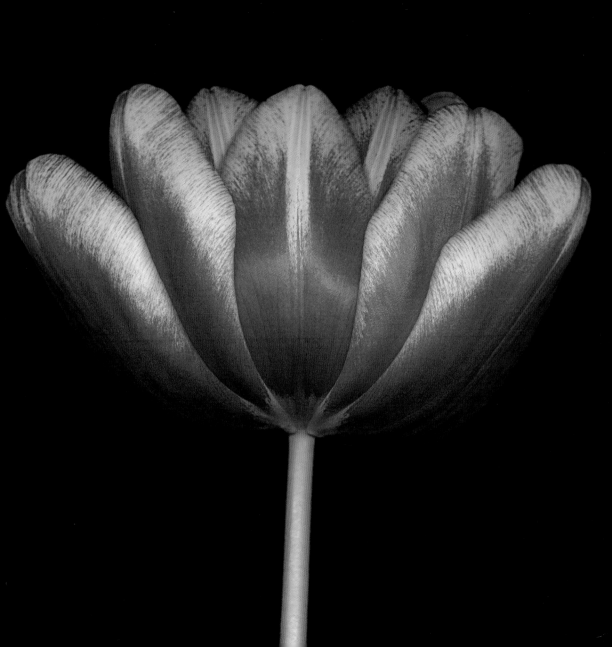

PASSIONALE

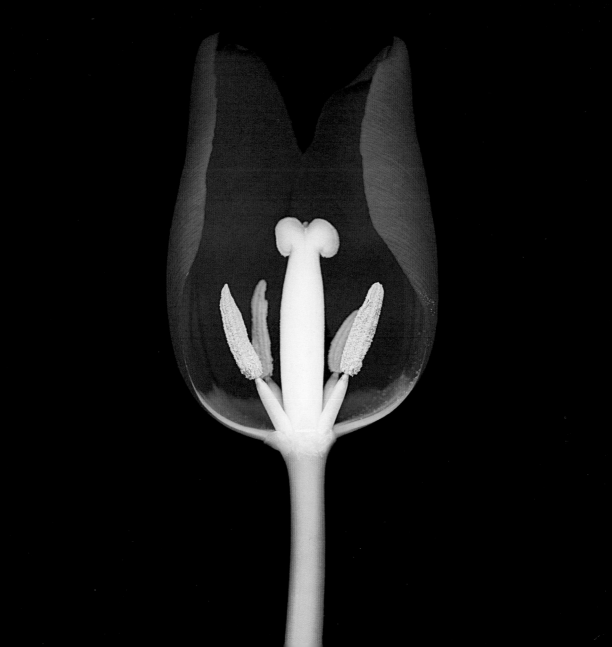

PINK BOUQUET

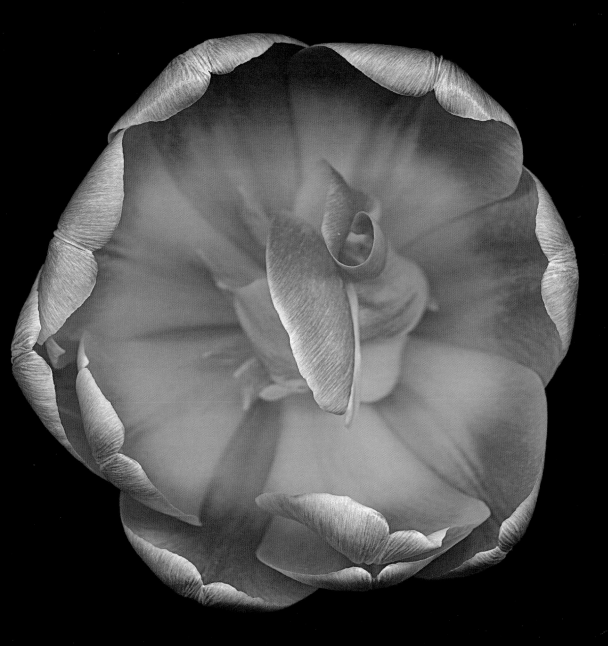

SPRING GREEN

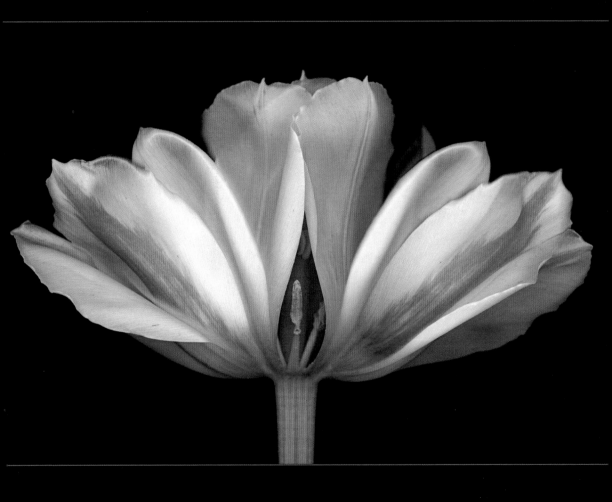

ARABIAN MYSTERY

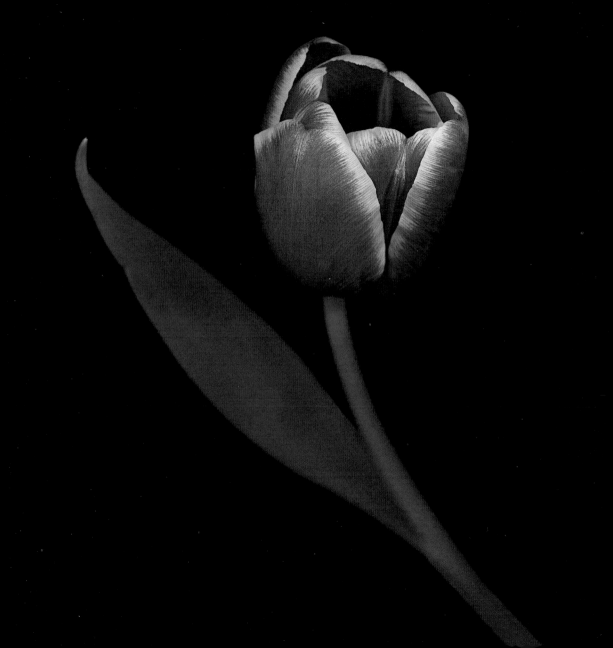

O'HARA TRIUMPH TULIP

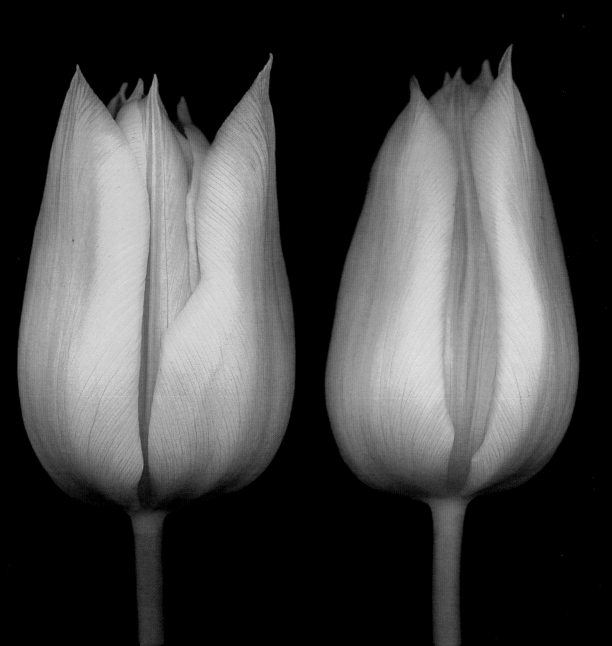

WEBER'S PARROT

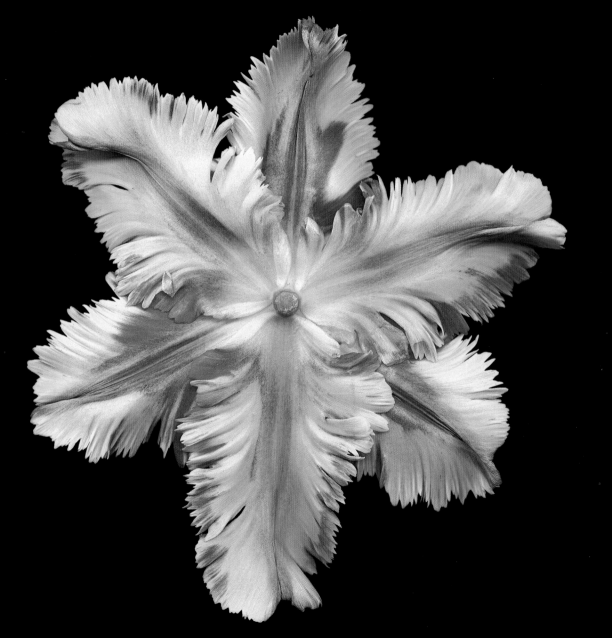

PARADISE

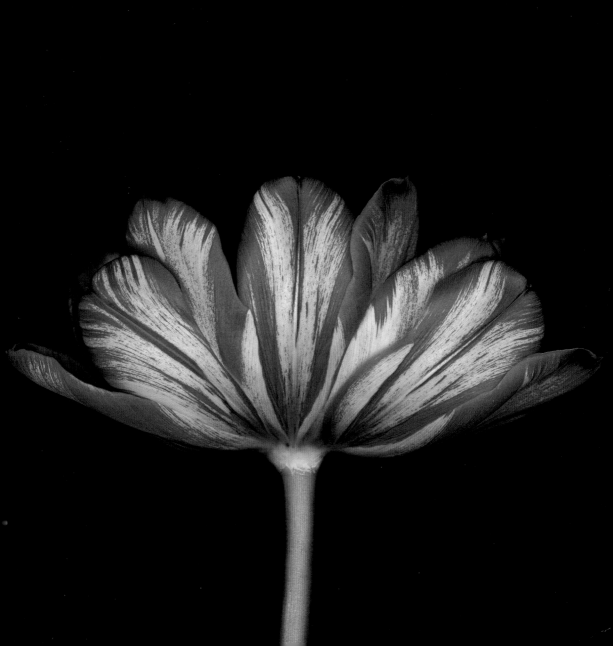

BLUSHING BEAUTY

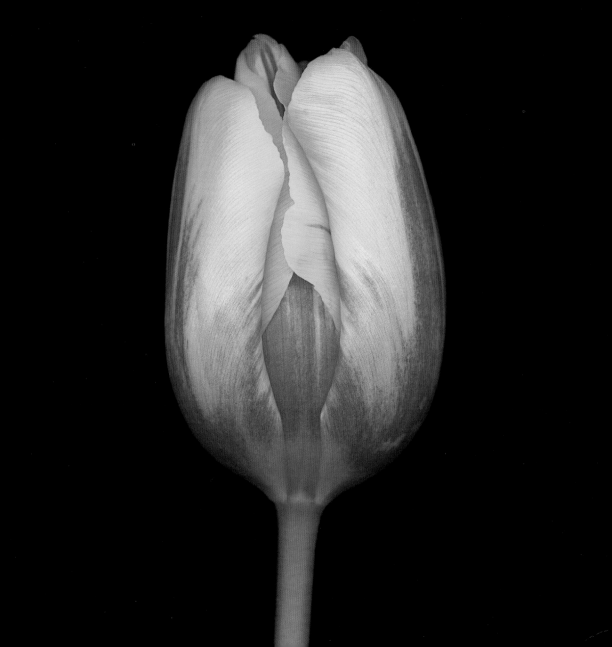

SPRING GREEN

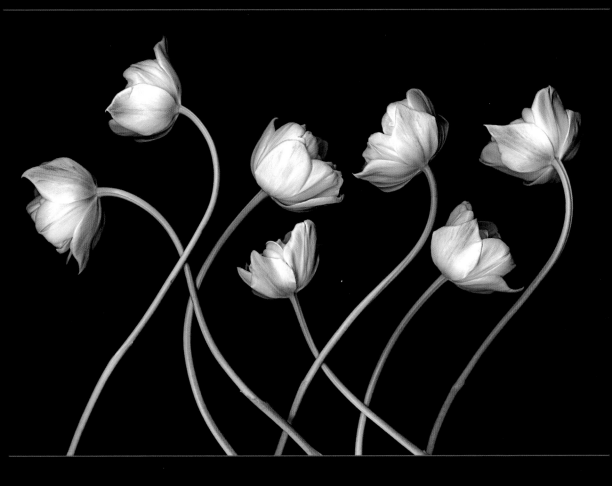

ROCOCO PARROT

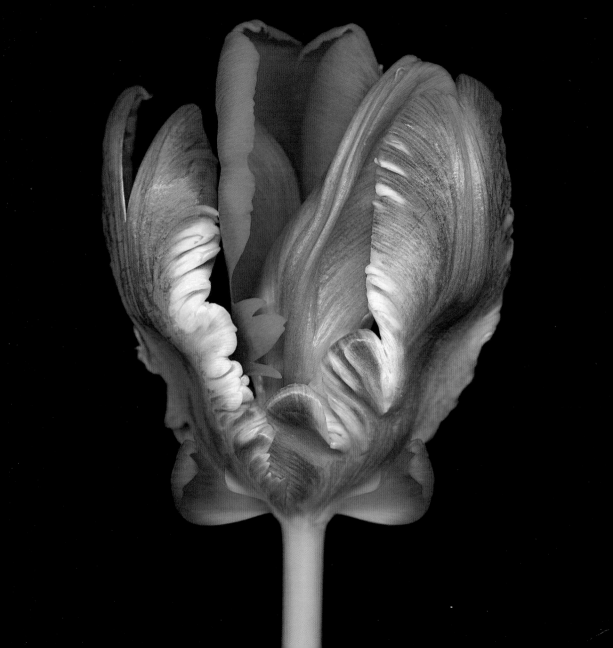

SPRING GREEN

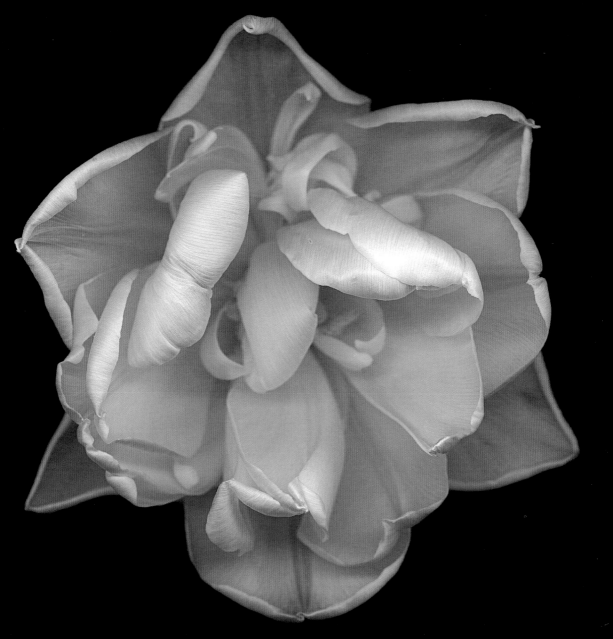

PURISSIM PARROT

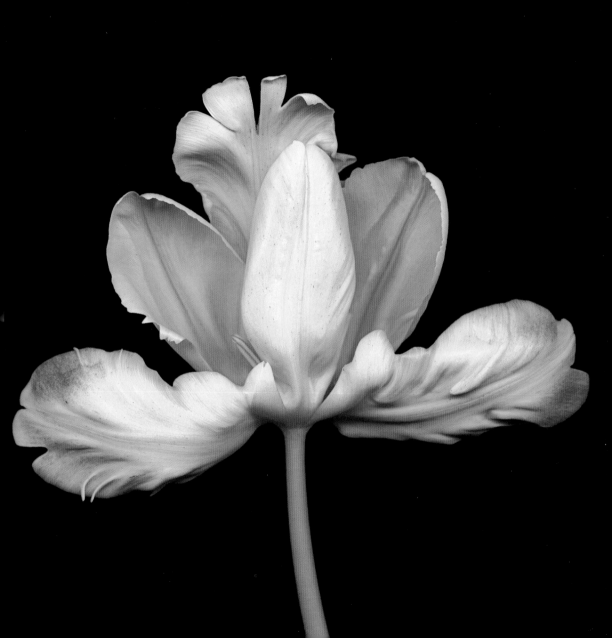

HYBRID DREAM

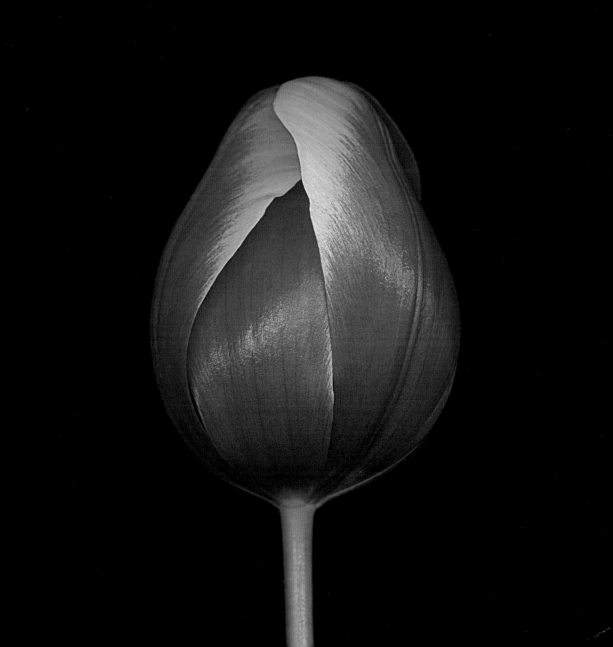

SALMON PARROT

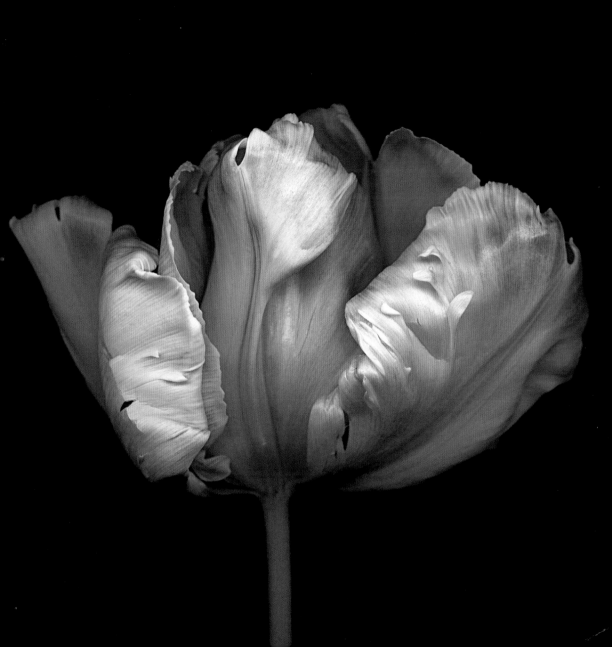

DARWIN HYBRID

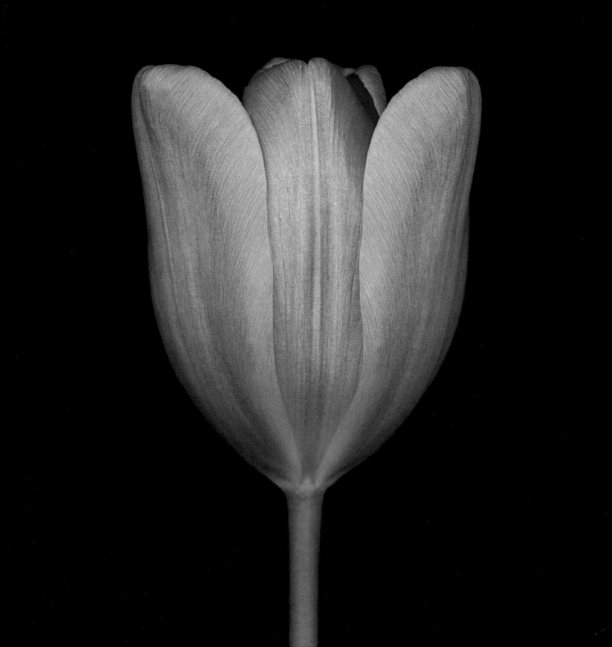

RED WHITE PARROTS

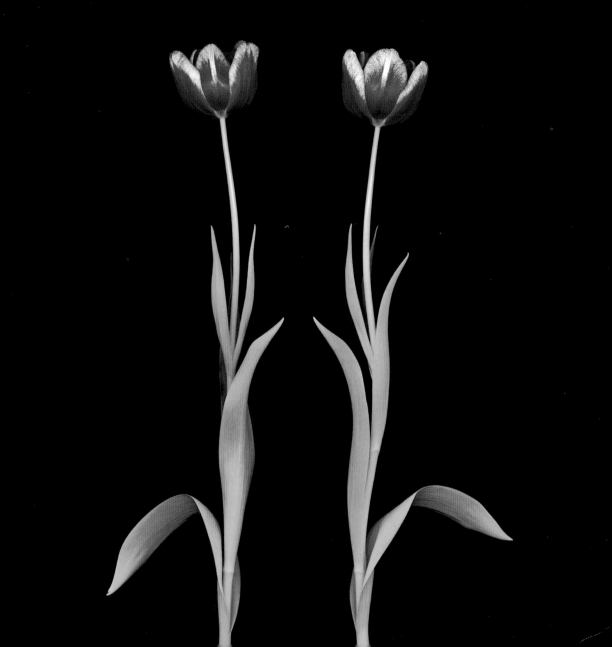

DUTCH FAIR

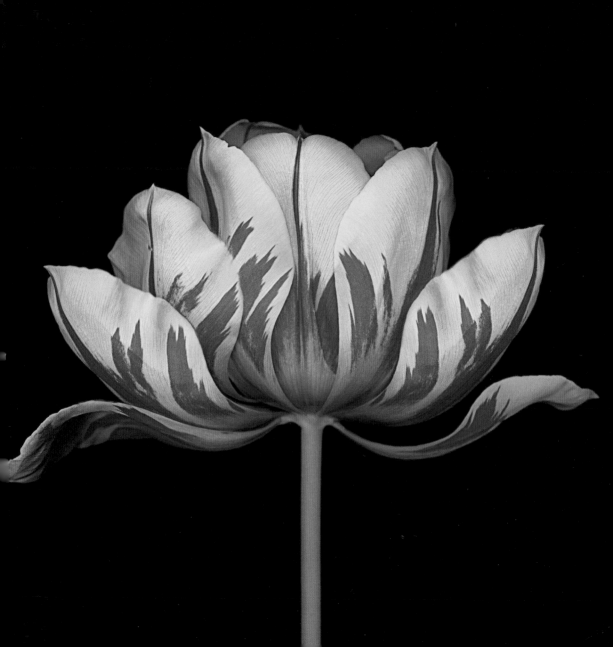

FRINGED PARROT

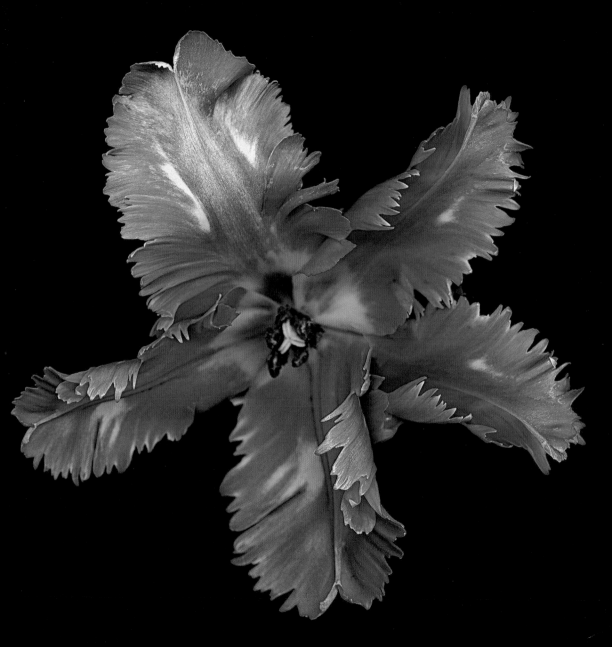

LEEN VAN DER MARK

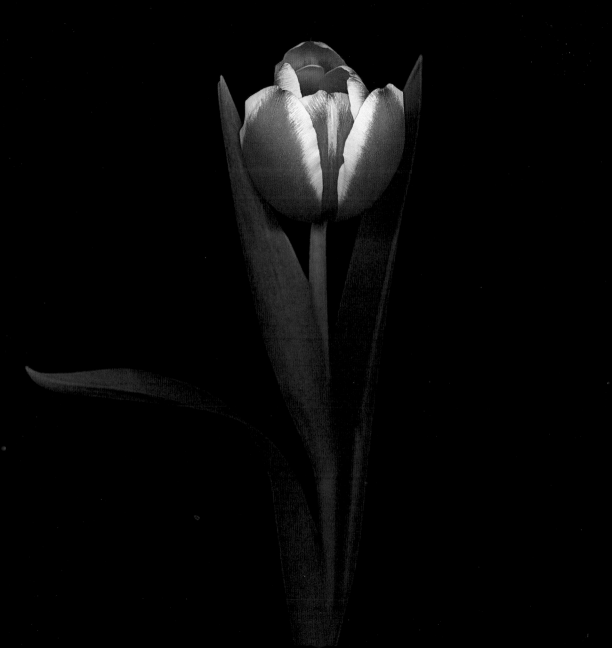

DOUBLE CIRCUS PARROT

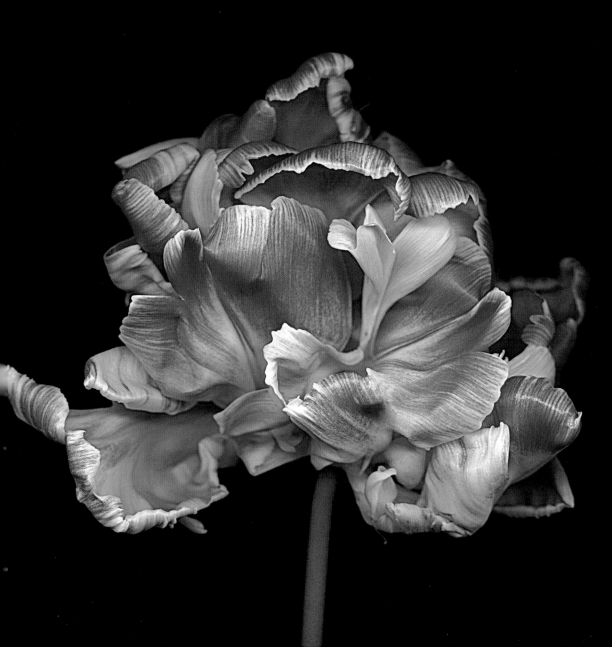

STRIPED BELLONA

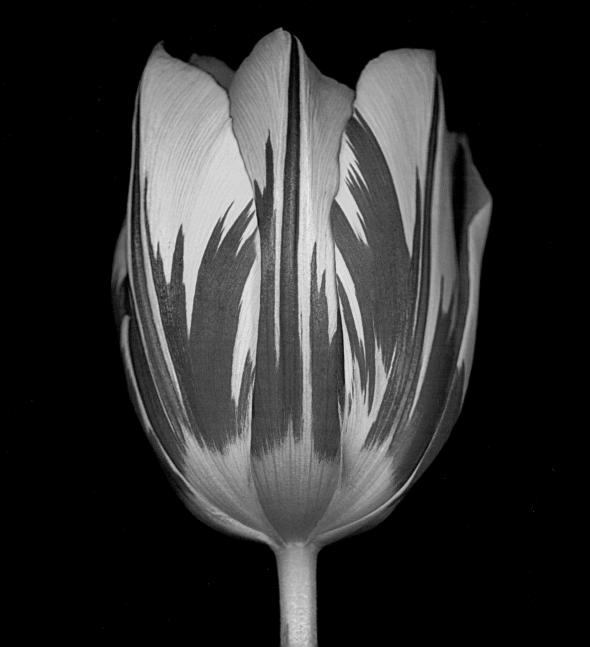

BEAU MONDE

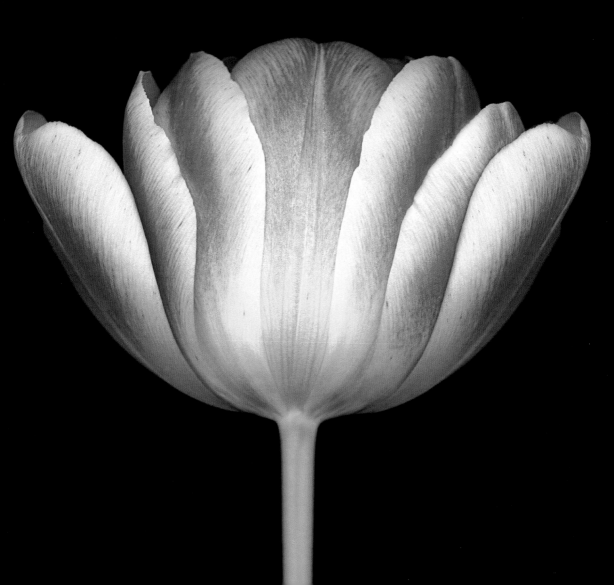

FAMILY CLUSTER

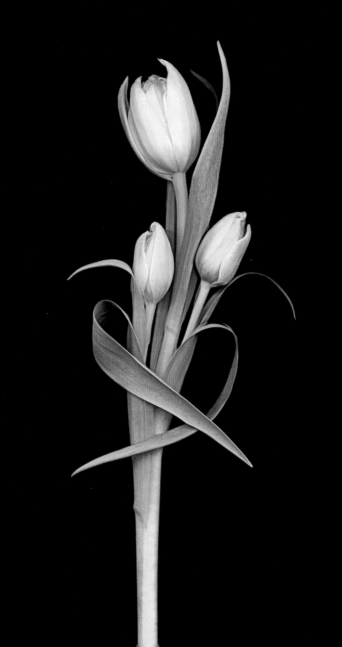

CHINA PARROT

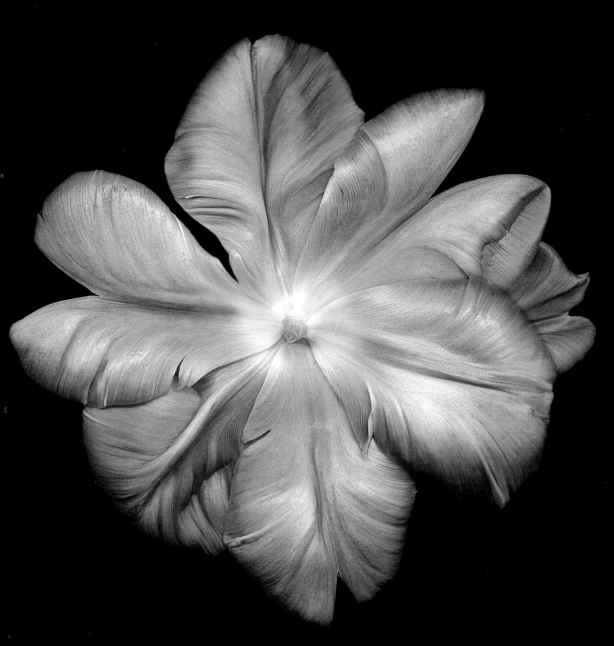

GREEN WAVE PARROT

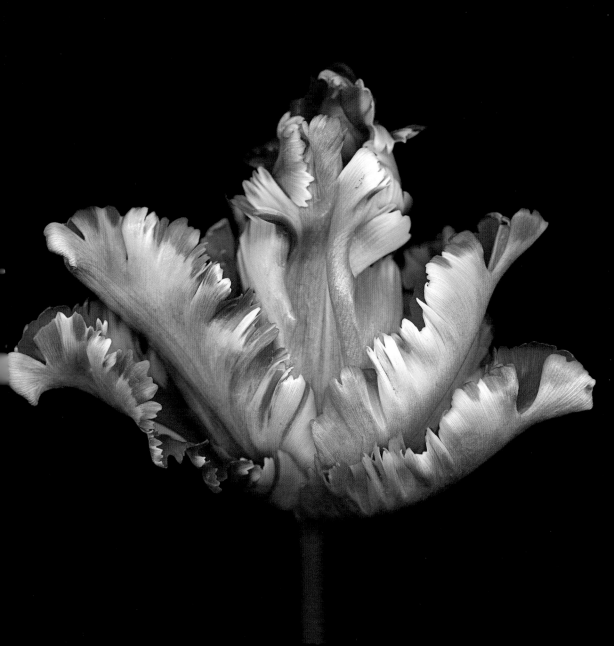

OPEN DREAM

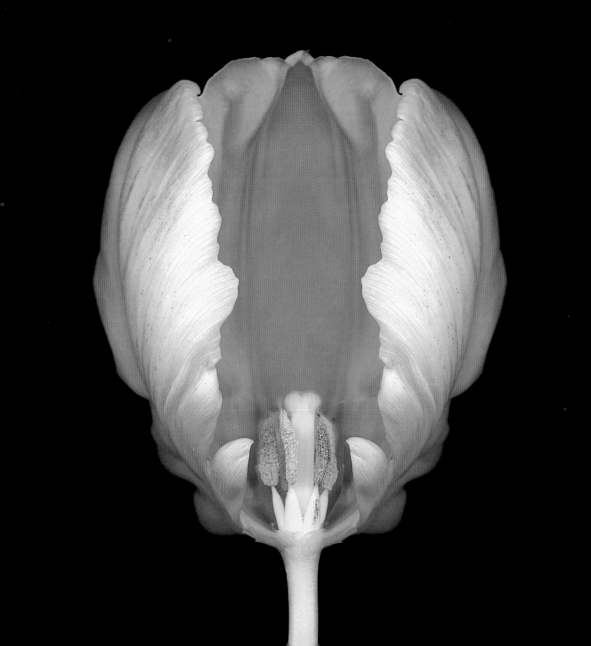

GAVOTTA

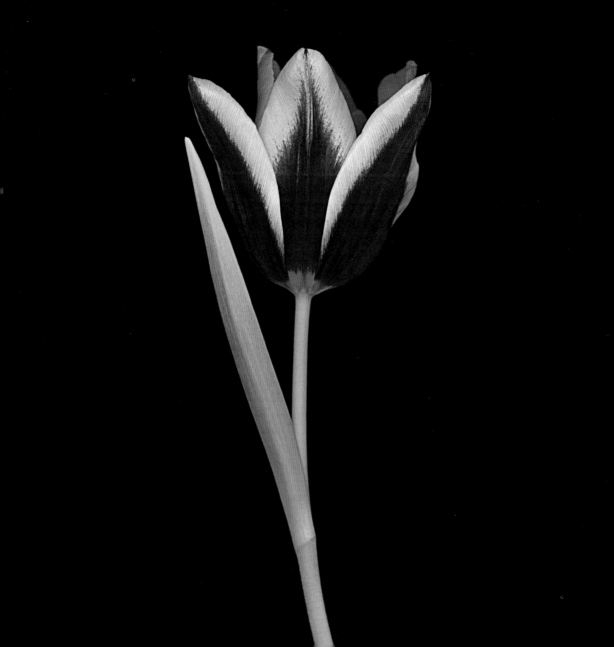

FLAMING PARROT

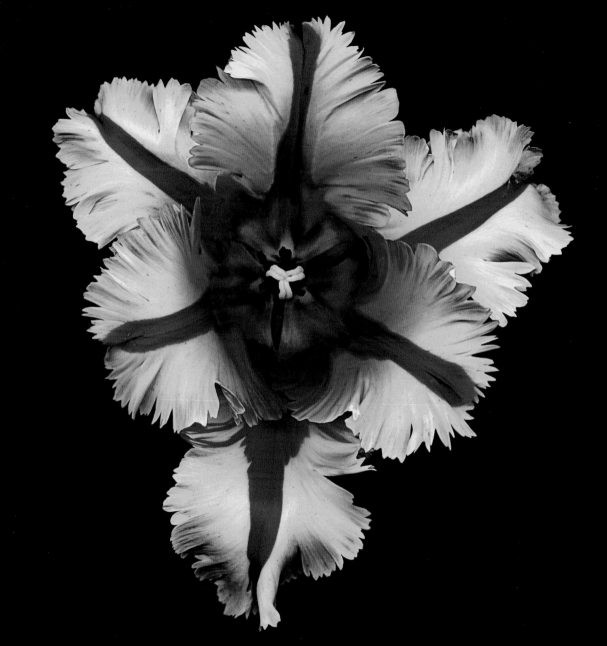

GREEN WAVE

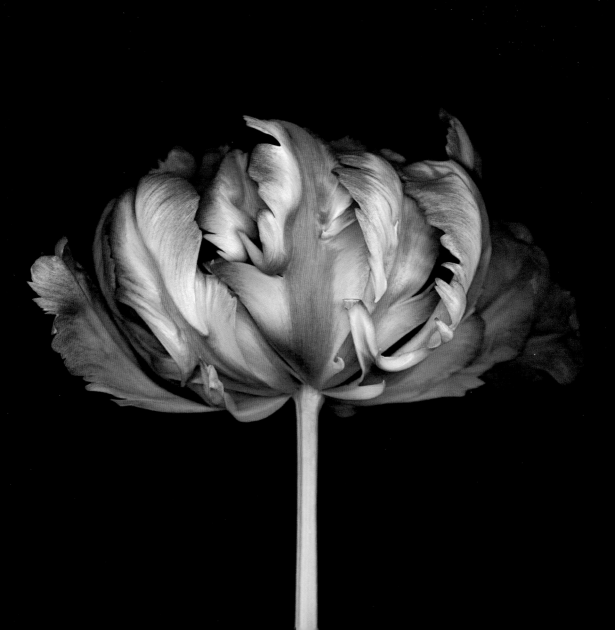

PRESIDENT KENNEDY

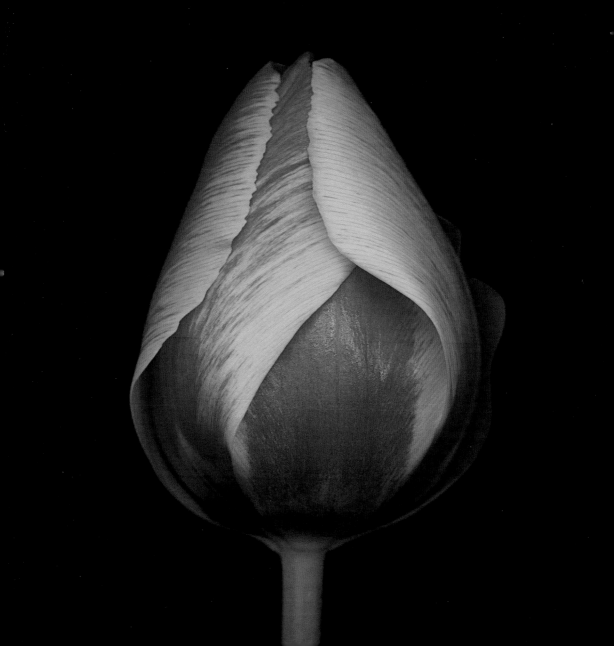

FLAMING PARROT

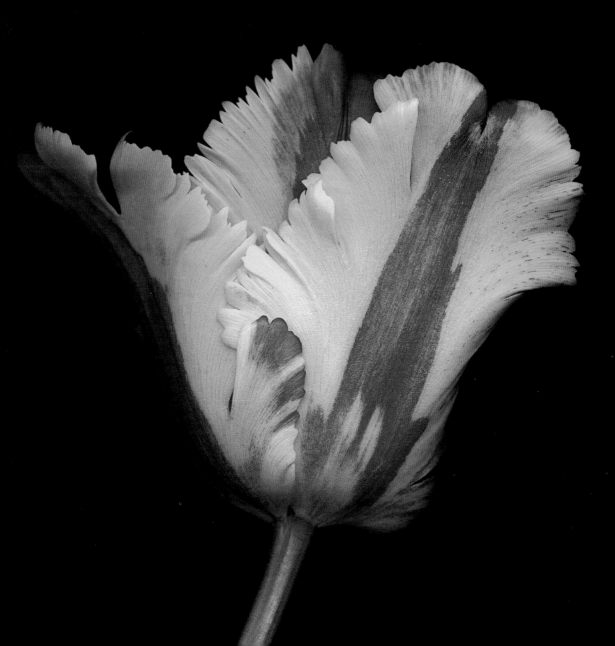

ESTHER

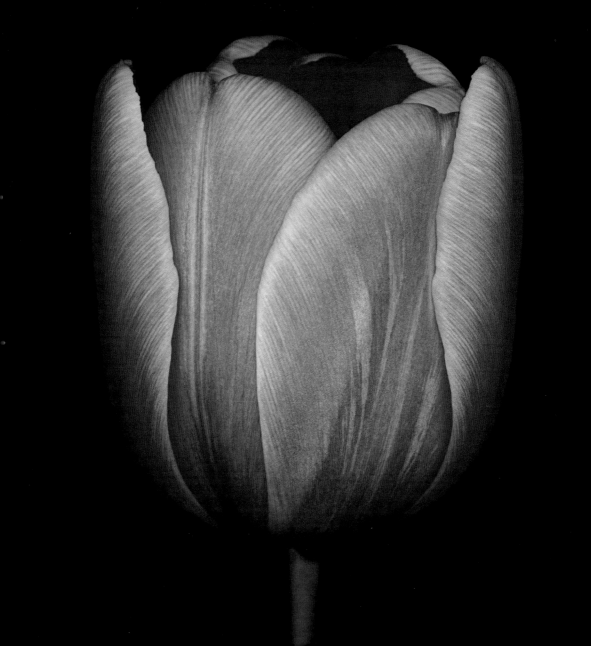

APRICOT PARROT

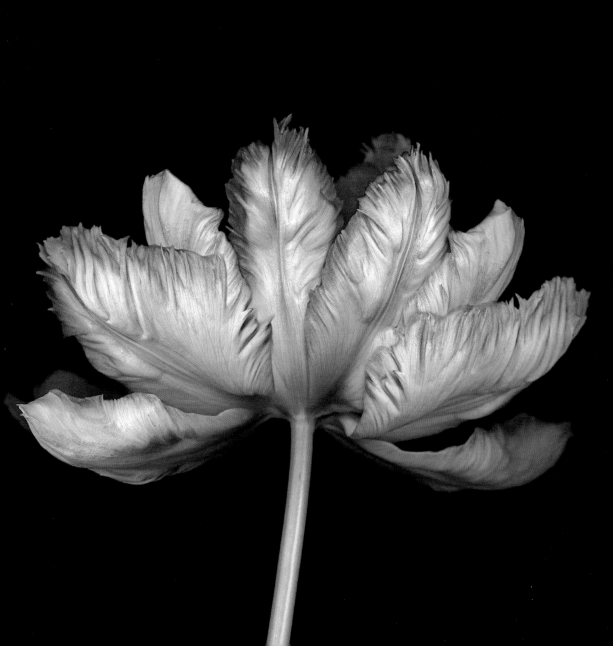

PARADISE

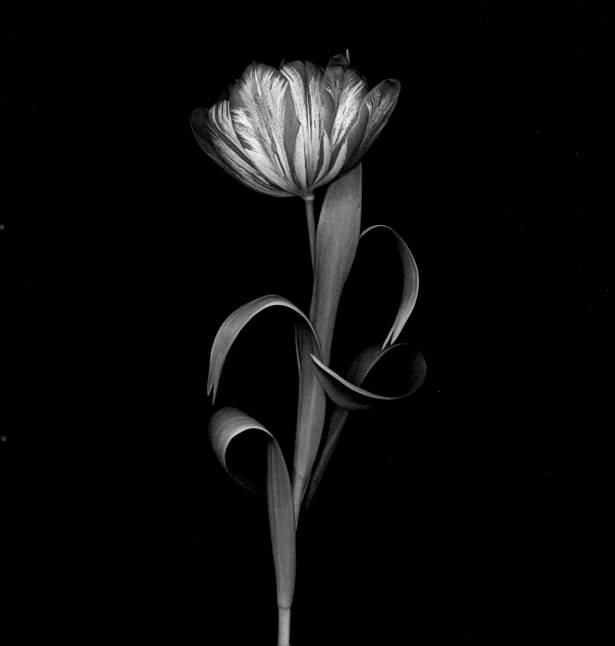

FLAMING PARROT

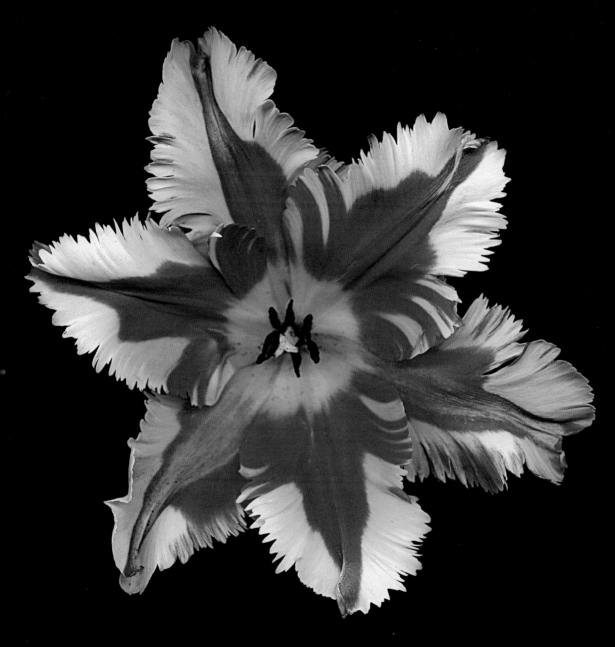

YELLOW SMILE

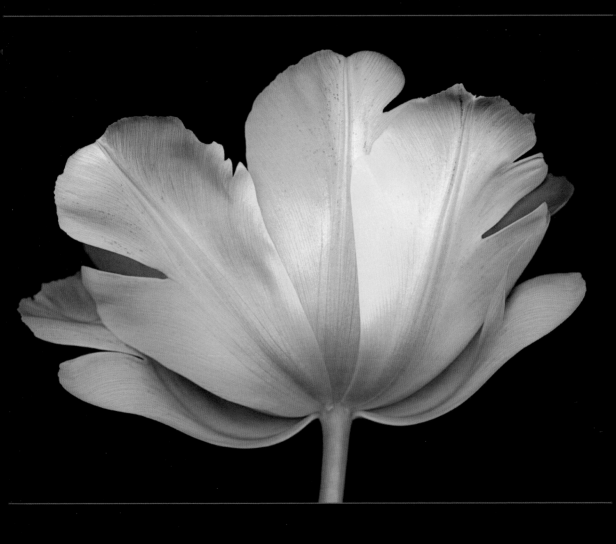

QUEEN

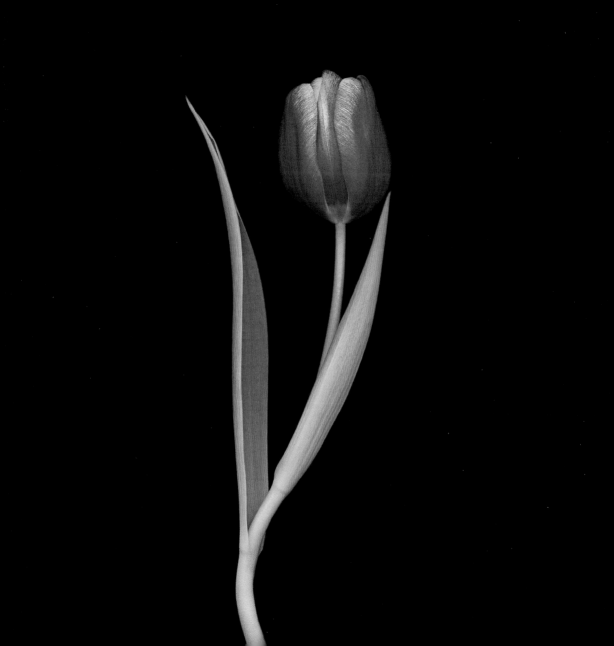

ARABIAN MYSTERY

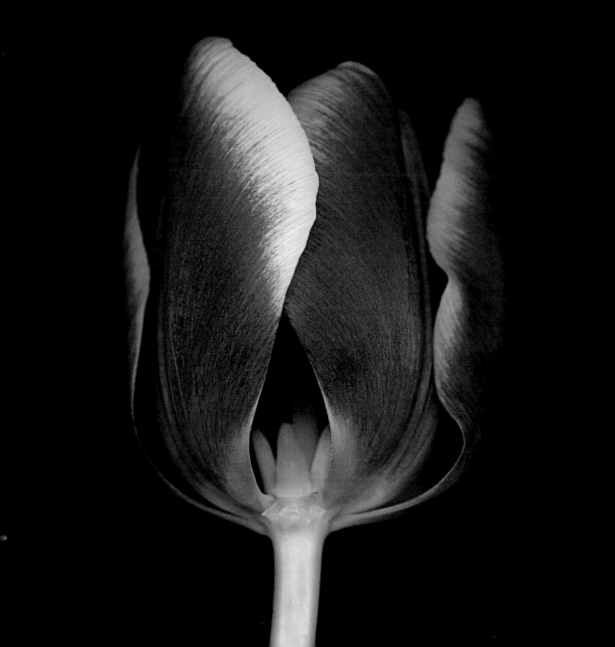

TULIPA ELITE

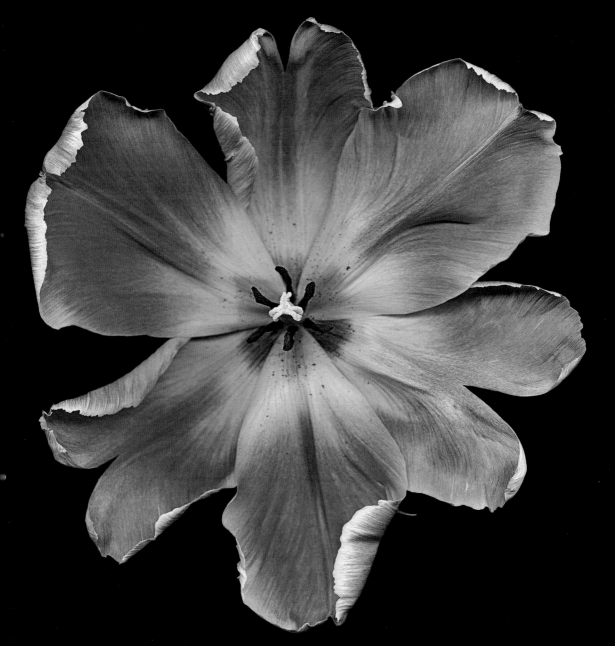

PARROT TULIP HYBRID

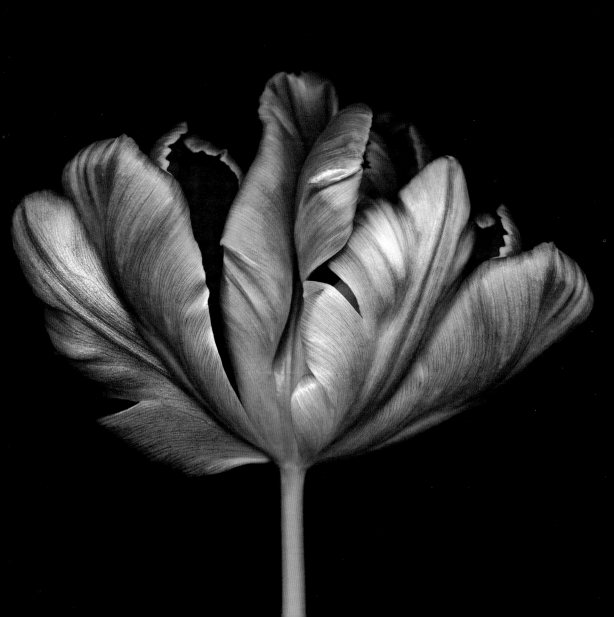

PARROT TULIP BOUQUET

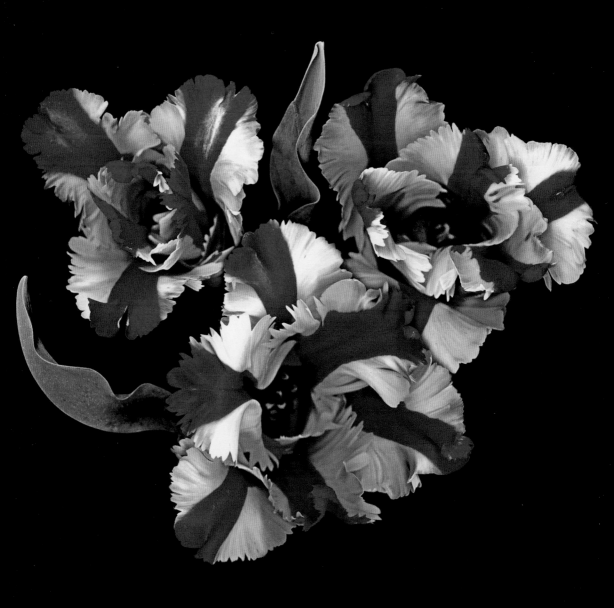

ORANGE PROMINENCE

OVERLEAF

APRICOT PARROT

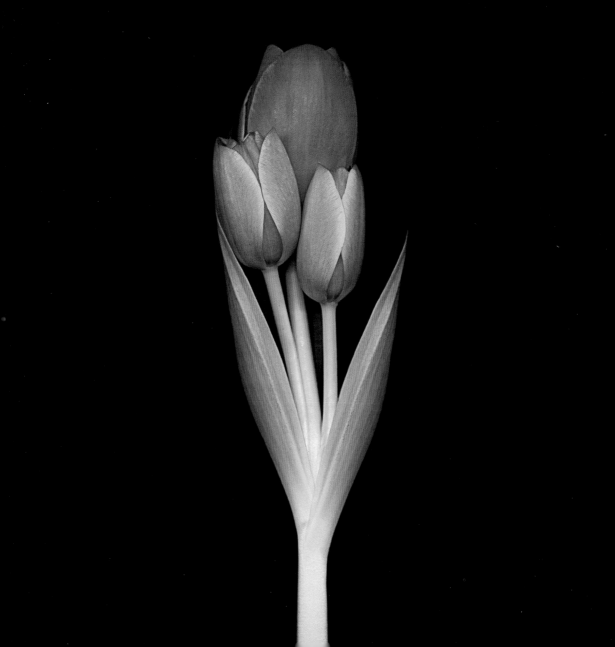

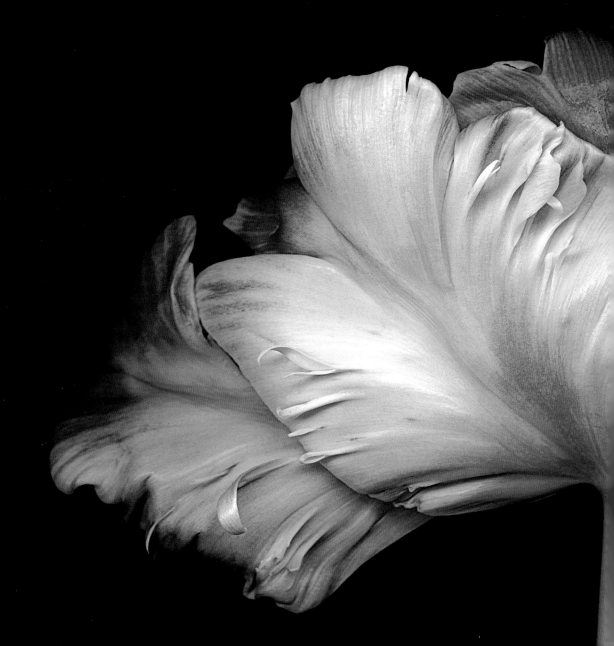

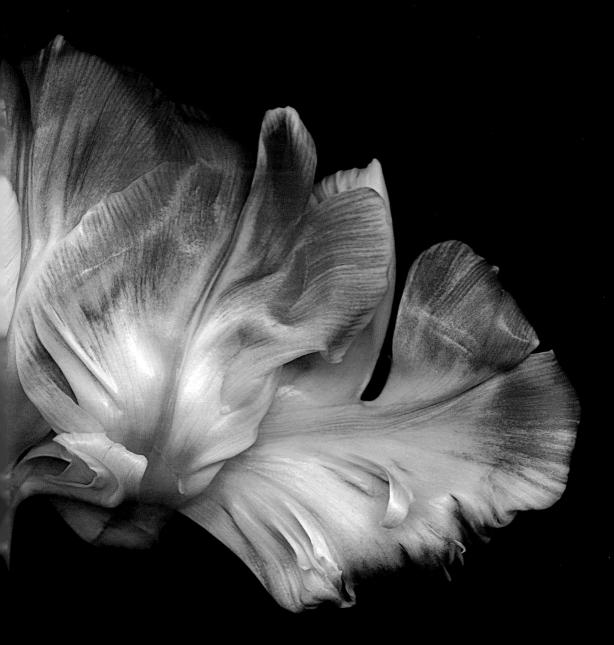

CAPE COD PARROT

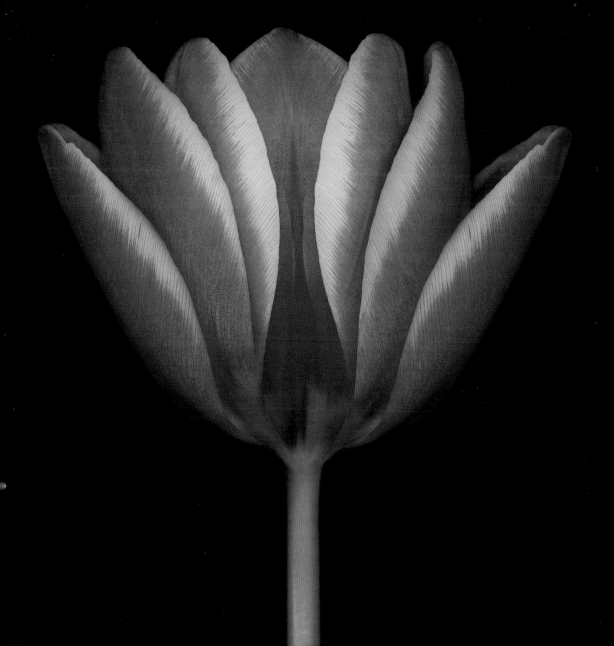

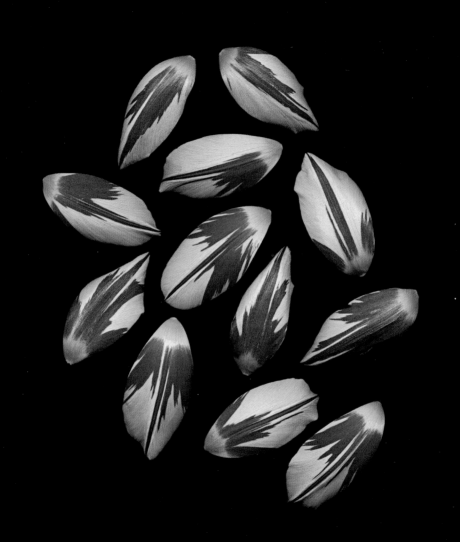

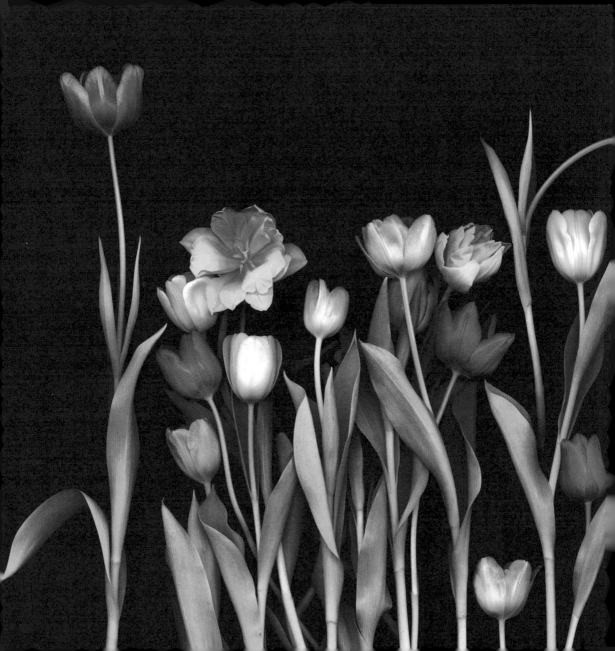